FOREVER 21

Phil McClean

authorHOUSE®

AuthorHouse™ UK Ltd.
500 Avebury Boulevard
Central Milton Keynes, MK9 2BE
www.authorhouse.co.uk
Phone: 08001974150

First published by AuthorHouse 10/14/2009

ISBN: 978-1-4490-0324-1 (sc)

This book is printed on acid-free paper.

All characters in this publication are fictitious and any resemblance to real persons, living or dead, is purely coincidental

Contents Listing

Foreword

This collection of intriguing poems certainly hits the mark. The author from the very first page draws you in, on what is quite a unique journey of adventure and interest.

Phil McClean uses his subjective powers of creativity and imagination to produce this well crafted, well-balanced offering of contemporary art poems. The spectrum of material here is far beyond that of many peers covering a wide range of topical subjects from protest, hope, love, adventure, pure fiction and humour to serious thought-provoking issues of the day.

The wide-ranging content written from fascinatingly different perspectives is what makes this book quite exceptional.

Enjoy!

PJ

Preface

I have thoroughly enjoyed producing this collection of poems.

Much of the material is a collection of snapshots of life occurrences, observation and experiences combined with much imagination and feeling.

I started off penning one or two poems after a trip to Greenwich and was encouraged to write more by my children and wife and from there on things just grew.

As time progressed I wanted to ensure I gave the reader more than just 'another book on poetry' but something far more intriguing and unique -hopefully that's what I've achieved – if so it'll have made it worth the while.

I struggled to decide what to call the book but decided eventually on a title of one of the poems that has a certain timeless, yet meaningful eminence.

You'll notice that a few of the poems are pretty hard hitting and that's how I intended them on the day of writing; I thought about toning them down a little, but decided to leave them as they were, and not lessen their depth in any way.

I hope you enjoy reading it as much as I did producing it.

Gold in your Hands

(You may not know it but…)
You've got gold in your hands
read on and understand
it's like 'you couldn't fly
but now you can'

I can go anywhere that I choose
and do anything and never lose

We're all spinning round together
on this rock, that won't last forever
So be good to your sister
and don't forget your brother

Never 'short change' the crew
and do the best that you can do
Don't be like them -
burning up before our eyes
all that deceit and all those lies
and we may just make it through

We're all going to be forgotten
at some point, when we're all gone
There'll be no one to remember
our existence, all our love or lies

(At least for today…)
You've got gold in your hands
read on and understand
it's like you couldn't fly
'but now you can'

and I'll take you places you've never been
to see things that you've never seen
from the Grand Canyon to the Rio Grand,
the Fight for Freedom and the Last Stand

So come aboard my sky liner
nothing could be finer
cos we're going on a journey
I know it's very unlikely
but it may just change your destiny….

Madison (your song)

"You raised your glass just one too many times
and cannot remember your lines
The swifts and swallows are long gone
and the sun, it no longer shines

You filled your body full of chemicals
asked why you did it you'd answer 'just because'

It should've been your summer – but the rain fell hard
so much so, you couldn't see the way ahead"

Madison, Madison you were the one
- the light and warmth, you were our sun
and what are we going to do, now that you've gone?

Last I knew you were shining bright
but something went and turned your day to night
I know sometimes these things happen in life -
circumstance and reason, place and time
or a particular liaison, but I missed the signs

'Ashes to ashes, dust to dust'
how sad is that, as she was laid to rest
and I ask myself what about the rest of us?

No one knew, understood or cared
and too few tears on that grey day were shed
If it wasn't for the few mourners memories
Madi could almost never have lived

It would have been nice to make you happy Madison
but you went away, and now you're gone
I can still remember you singing in the school band
'a star of the future', that's what Mr Jarvis said
and that's what you were to all of us

I think back to all those good times
but it's true, nothing that good can ever last
and if you ever get one you've got to grab your chance
with both hands and don't let go
and hold tight, like me to your remembrance

I recall your warmth, in which hearts could melt
you deserved so much better
than the cards you were dealt

I often wonder how it all went wrong
especially for you, as you were so strong
Is it really all down to fate?
- whatever, I'll have to accept it, any way
But please have this one on me Madison
Our last 'goodbye', this is your song

The Dustman and The Gravy Train

The dustman and the gravy train
he went to the west coast, to L.A
He'd heard things are so much better there
and that those that win are those that dare
He observed high society and their role
to learn how best to achieve his goal

He headed straight up to the Hills
and observed the 'stars' and their cheap thrills

He soon learnt that the important things like health
honesty and pleasure are not relative to wealth
and so in search of the 'holy grail'
he felt as though perhaps he'd failed
until he opened up his eyes and looked above
and realised the answer was peace and love

The dustman and the gravy train
he sought his fortune, but never fame

The dustman and the gravy train
they said that no one was to blame
that us 'lowlifes' like me and you
could never compete with a high class fool

But I think he was right though when he said
'you won't change a thing by staying in bed'

He was like a sponge, wanted to learn more
but they wouldn't let him through the door
- 'no gutter trash here, you're far too scruffy
this is an exclusive establishment and you need more
money'
to me it says a lot - so much for 'high society'

The dustman and the gravy train
he cleared the rubbish, but liked to dream

And so he headed for Down Town
where he felt more at ease with those around
but while making his way back through the park
was jumped from behind in the dark

They took his last few dollar notes
which he'd planned to use to get home
disillusioned and 'roughed up'
he had just enough change for just one cup
and so sat down with his tea
and took out his diary
he wrote that no one cared, but he was wrong
and read it back and wrote this song:

The dustman and the gravy train
I thought my journey was in vain
but searched deep and looked above
and realised what I was looking for
wasn't wealth, but peace and love

and from that day things weren't so grey
and things seemed to come good again

The dustman and the gravy train
he cleared the rubbish, but sure liked to dream

Living Sounds

A microsecond in infinity
- some 'side-road' reaction
as if we were never meant to be
I better be quick and do something
before I become history
Yes we all play our part
in this cosmic 'back water'
that is planet Earth

The sounds of laughter from the street
as a group of young students meet
The sounds of living as a 'new-born' cries
And the far off wailing as an old man dies

Yes these sounds will carry on long after we've gone
No longer by us but by the kids of today
- tomorrow's people, the next generation

Everything comes and goes
- weather, moods, highs and lows
Bad and good, salvation lost and found
That's people, that's life – living sounds

Yes, Yes, Yes!; and a new-born cries
And the far off wailing as an old man dies

Protest Song

Protest songs of the sixties
Tell me what did they achieve?
'they painted rainbows across the grey sky
and gave us good reason to ask 'why?
to not be so naïve, yes they helped us to believe"

Here's another protest song
I knew all along
that it won't pay
But I think again today
there is a need

They call it democracy
It helps us to feel free
But we were deceived
for they've gotten too big for their boots,
and brought us to our knees
Spent all of our loot
and bitten the hand that feeds

We can see it now, you and me
Their priorities are plain to see
- money and votes
leisure cruisers and boats
and what they're all about is greed

Looking back we've seen it all before
only this time they've taken more
They never learnt a single thing
from all the heartache that greed brings
and left us all so poor

Ruth

You lived in a block of flats on the council estate
A bit run down and you were always late
but it never seemed to bother you, you were always laid
back
You didn't even give two hoots, the day you got the sack
Yes that's the way you were, the way I remembered you

Never one to conform to the system
you hated being part of the rat race
You would stick two fingers up in their face
but it never really got you anywhere
and you still live in the same place

For reality is not always kind and, the truth be it known
you're all alone
But for a screaming baby for company and no-one
phones

Oh Ruth, why did you go and change
we loved you as you were
you were unique in this world

As you got older your circumstances changed
you became a different person, a little deranged
All of your mates that you grew up with have long since
moved away
You have fond memories of them coming round to play

Your latest neighbours turn their music up there's lots of
them, a real crowd
you knock on the wall and shout at them to stop
But they can't hear you, for the noise is too loud
and even if they could they wouldn't be able to
understand
They don't speak the language see
having recently arrived from some foreign land

You lose yourself in a bottle of vodka
- a temporary sanctuary, the good memories of the past
But those times can never return
and the liquor inside of you is starting to burn

As for your new neighbours
it is their time, here and now
New-found riches, their friends visiting to stay
with them making good memories of today

You save up your social for your drink and once-a-week
baby sitter
Who looks after your baby son you made with the tyre
fitter
You hear it all going on and it makes you feel worse, sad
and bitter
you complain about the state of the place, but it's you
that drops the litter

You're in a rut, but it's not your fault
like the day you tried to steal a bottle from the local
store
it had been raining, your hands were wet, and it slipped
and broke

and somehow you didn't get caught
but you still cursed your luck
blamed the bloody weather, a good day for ducks

I often wonder how you're doing
and think of you playing happy families
may be somewhere in the Home Counties
that you may have moved away to, Ruth
But some things are better for not knowing,
as in this instance like the living proof

Oh Ruth, why did you go and change
we loved you as you were
you were unique in this world
Now all you've got to show for your days on the fags and
gin
is an empty wallet and dried up skin
yeah if only the good old days would come back again
(- for you and me both)

The Man in the Moon and Mr T

As the night comes rushing in
and the man in the moon says 'hello' again
It's the end of another day

I wish time would sometimes slow down
and also that you'll always be around
but I know that you'll soon be on your way
soon be on your way

I sit there sleeping, still holding my glass
dreaming of great times that have long since passed
Why is it that good never appears to last

And won't you please slow down Mr T
I've still got so many things I wish to achieve
- but you're a bad sport Mr T
and you won't be coming out to play
and I sense you're running out on me
What do I have to make you listen? 'plead!'

But Mr T, have you no emotion?
It's like you work for the LAPD or something
Some sort of fascist dictator that is the law
that rules our lives, we can't ignore

Mr T, Mr T you're the holder of the key
Tell me, won't you ever let it be
But no, I think you've got it in for me

But I could be holding an ace up my sleeve
as I place my last card on the table and turn to leave
I look back for just one last time
as Mr T turns it face up and I notice his smile
soon fades in the light of what he sees
the single word that can mean
so much to everything we've ever been or seen
He says the word on his way out – 'eternity'
It's good for job security but
he's got a job on his hands has Mr T

Drug Society

Guns and knives ruin lives
in our drug society, drug society

Crack, coke and weed
Yeah heroine and speed
addictive foods on which we feed
drug society, drug society

Down the Club you did show
you said 'yes' cos you couldn't say 'no'
- wouldn't face reality, never liked sobriety

It is becoming part of our culture in this land
don't accept it, let's make a stand
against this drug society, drug society

You turned to crime to feed your addiction
to pay for more, there were no restrictions
You do a 'St George' when you're feeling low
or a little push and let it go
and you're feeling all right again,
for a while any rate, you mask the pain
at least when you're feeling high
a temporary fix, cos you're living a lie

drug society, drug society
we're free falling into anarchy

drug society, drug society
lawless gangs roaming our streets

And poor old Mrs Rose
she won't go outside tonight because she knows
they'll be there again, hiding in the shadows
They'd mug her again, just like before
and they would just to pay for some more
How many wasted lives must there be
before we face reality, and try and mend society?

Let's join together, hand in hand
don't accept it, let's make a stand
against this drug society
drug society

Light it up when you're feeling low
Breathe it in and just let go
Far more potent than it used to be
Satisfaction guaranteed
or not as the case may be
not as the case may be

You don't have to listen to me
but don't do the white lines please
and keep your sanity, keep your sanity

Scheming Sheila

You were a scheming Sheila
now I'm making my own plans for you
You're selfish and don't mind what you do
to the people that you use

Scheming Sheila, scheming Sheila
I did my best to please her
But it was all in vain
It was all part and parcel of her wicked game

She laughed at all my jokes
she made out she was rich, when she was broke
You took me for a fool
but at least I found out your first name

You are a Scheming Sheila and now you're gonna pay
especially now I can see through your ways
You led me down the 'garden path'
but this time I'm gonna have the last laugh

I fell for you hook, line and sinker
It was my fault I should have seen her
for what she was, a 'wicked Sheila'

Scheming Sheila, Scheming Sheila
listen to me, don't believe her
even though she sounds so sincere

This time her numbers up
the pennies dropped and I've sussed her out

She's like a bloodsucker
- she'll bleed you dry
And it'll be too late before you ask 'why?'
But this time I am aware
and I'm making plans, so beware
It'll be pay back time pretty soon
And the timely downfall of this Sheila of Doom

Scheming Sheila, scheming Sheila
I did my best to please her
But it was all in vain
It was all part and parcel of her wicked game

Back on Track

I can't help who I am
- I was born this way
but I will always try and learn from my mistakes

For there have been a few
well many more than that, if I am true
You'd think I'd know better by now
but one of them was never you

You showed me a better direction
when I needed a guiding hand
Yes I remember then, not so very long ago
wandering aimlessly in the desert sands

You helped me to find my way back
I was desperate and the sky was black
But now it's bright and the sun is shining
and I can feel its' warmth on my face
thanks to you my darling

Words can sometimes sound hollow
and often shallow
But never with you, you to me are true
So thanks baby for sticking by me
for being my one in the manner that you do

Ability

Sometimes life it can seem a little rough
and just when you think you've had enough
Your strength of character will pull you through
believe me if I can do it, you can too

It seems like you're forever running up hills
wading through marsh, things can seem harsh
but you know what they say, 'where there's a will
there's a way'

Always have faith in your ability
and never lose sight of where you want to be
Always have faith in your ability
Have belief in yourself and you will see

There's good, there's bad
there's fun times, there's sad
Life has its' ups and downs
ride those waves and turn things around

Some say there can be too many restraints
Now is your time to break free from those chains
keep on trying and you will succeed
for your time is now to be freed

Life's for living
you can't give it up

Life's for giving
so drink from the cup
Enjoy yourself today
and don't let others stand in your way

Big Shot

There are some young 'pretenders' in Town
and they're after your crown
And you may be the greatest of all
but even the champion of the world has to fail
at some point, so revel in the glory
while you're still the main story
and you're still front-page news

Big shot - you're gonna be in trouble
Big shot - you're gonna hit the deck
Big shot - I'm gonna burst your bubble
Big shot - I'll give it what I got

The young guns are waiting in the shadows
they can't wait for the chance to prove themselves
and those that rush in get blown away
but there's one preparing for another day
with sweat and tears, bruises and cuts
power, pain, blood and guts
passion and nobility
craftsmanship and beauty
for all to see on Big Fight Night

Words don't matter anymore
it's actions only that count in the ring of war

Big shot - you're gonna be in trouble
Big shot - you're gonna hit the deck
Big shot - I'm gonna burst your bubble
Big shot - I'll give it what I got

FM Young Ladies

FM young ladies
swear in front of babies
Where as they used to sing a song
and the babes would hum along

Everyday I see spite and evilness and I ask myself
'Do I really want to be part of this?
Cos I don't understand
Why people do the things they do'
As our castles turn to sand

We have high opinions of ourselves
- but we are only animals
We have no divine right
to bring species to extinction
We should all be praying at night
together, regardless of religion

Our future's is in our hands
We must change and start to care
or else it will be too late
Got to start to appreciate
our privileged position in the chain
So please never forsake us
we should know right from wrong
before we turn to dust

(We are lost children of the wilderness
wandering blindly through this mess
and maybe we wouldn't be here now
If it wasn't for our greed and selfishness)

FM young ladies
Swear in front of babies
Where as they used to sing a song
And the babes would hum along

Everyday I see spite and evilness and I ask myself
Do I really want to be part of this?
Cos I don't understand
Why people do the things they do
As our castles turn to sand

And the whole world seems crazy
In the park amongst the daisies
the peace is broken yet again
How I wish they would refrain
but at least you're not the same

Pray

Do you believe in spirit and soul
or just in the physical?
Principles and ethics are
good things that make us who we are

I'm mixed up and confused today
Don't know if I'm gonna pray
But I do, but I do

In this democracy of decadence
of thieves, killers and rapists
Some things don't seem right to me
in this land of the free
But what can we do, what can we do?

You can pray, to who you want to pray
You don't know why you do
But you do it any way

We're hurtling through space and time
and from a distance things look fine
But when you take a closer look
time has not been that kind
to planet Earth

Even if we try to mend our ways
I am starting to recognise
that we're heading for a fall

Oh dear what have we done
all our pollution is blocking the sun
- and the sky is no longer blue
and I'm feeling blue, how about you?

You can pray to who you want to pray
You don't know why you do
But you do it any way

Decadence and Charity

Decadence and charity
initiative and fantasy
Take my hand and come with me
where we're going, you won't believe

- And only I can take you there
as we fly high above the sky
shooting stars, and moonbeam
sunny days that last forever like a dream

We'll take a look at supernova and galaxies
solar systems and planets
we're in no rush, but no matter see
it's a vaster perspective of relativity

There will be a time when we'll have to go
even though there's so much more to see
Don't worry I won't leave you here alone
but I think it's time we headed home

Way back down to the Earth
a place where time moves so fast
and if you move too slow, you'll finish last

But no worries for I have a key
to some mansion by the sea
So, take my hand and dine with me
and this time next year
who knows where we might be

Decadence and Charity
I wonder if I asked her to
would she marry me?

Bully, bully so uncool

Bully, bully, you're so uncool
and what you do is unacceptable
the only thing that you seem to achieve
is unease and a load of grief

Bully, bully, we can see through your ways
why don't you start being nice for a change?

Think about all those, who you abuse
and for a change put yourself in their shoes

If things go wrong, you blame everyone else
that's no excuse, when you should blame yourself

You take out your frustration on the softest target
like any coward, you know it's true
but you choose to forget and you never learnt to lose

Bully, bully you're so untrue
Bully, bully you should not be so cruel
Bully, bully you're a king sized fool
it's no wonder no-one likes you

He Say, She Say

He Say, 'How about it baby'
She Say, 'you must have read my mind'
He Say, 'lets get it together –
Come on baby pull the blind'

Woke up in the morning
She said I'd been snoring
I'd left smelly socks on the floor

The place is in a mess
Time to tidy up I guess
How I wished I'd done it before.

She Say, 'I really love you baby
& what I'm thinking of just lately
Is settling down with you maybe
if you clean up your messy ways'

He Say, 'I'll really think about it'
She Say, 'You better do for sure'
He Say, 'I'll really think about it'
She Say, 'for richer or for poor'

Woke up in the morning
She said I'd been snoring
Nice clean socks in the drawer

She tidied up the place
Not even a trace
Except for a book on the floor

He knows he's falling for you baby
She knows she could be his lady
They are both in-love-crazy
And I think we all know the score

Black Widow in a Velvet Glove

You're a Black Widow in a velvet glove
a quick glance and you'd never know
No shrinking violet, no white dove
no, no, no you came from somewhere below

First impressions of a damsel in distress
looking pretty in that little red dress
couldn't have been further from the truth
You're as hard as nails, mean and tough
like old boots, and enough's enough

Cool as an old pro' of a cold-blooded assassin
I couldn't see it coming
No one could've seen the gun you were carrying
(in your bag with your lipstick and crack)
It didn't bother you to shoot in the back

To you it's just another score, another scalp
I was just one of a number
another feather in your cap

You were like no other
when you came forth
like an ice maiden from the north

Looks can be deceiving, cos she looks like a diva
you know what I mean; it just goes to show you

No, no, no you don't want to go near her
especially if you suffer from arachnophobia,
arachnophobia

Some of Us

Tell me what you think
is there really such a thing as too much freedom
and if so could it be a bad thing?
'Take a look at us for a moment, our many failings
we're prone to selfish greed and addiction

That said freedom's fine in theory'
yeah but does it work in reality?

'Well, let's look at the land of the free
It's a nice place to live but you know what I mean -
guns 'n' drugs on the streets,
unrestricted internet access
& fast food consumed to excess'

I am selfish
Some of us are lazy
Some of us are wicked
And some of us are crazy
They're all part of human nature
part of our psyche

Knowing what we do doesn't make things right
sometimes to make things better, you've gotta fight

Complete freedom sounds good in theory
but can lead to anarchy

Wouldn't it be nice a society built on trust
where people don't need to lock their doors?
'Yes I agree it would be great
But remember the flaws:'

I am selfish
Some of us are lazy
Some of us are wicked
And some of us are crazy
They're all part of human nature
part of our psyche

You need some restriction
when you've got child abduction and paedophilia
So commonplace, it's not covered by the media

Gun crimes and college shootings
Downtown L.A. lootings
Unchecked mass immigration
but we're told it's good for the economy
Not to worry, so that's all right then
After all it's the Land of the Free

I do love my freedom, it means a lot to me
it's something to be proud of and enjoy
something so important, worth fighting for
But just lately with the advancement of technology
just a few can wield the power of an army
'bombs 'R' us' off the internet, with the potential to bring
down economies

Surely that's not what they meant by democracy
Now's the time to make a stand for what you believe
before it's too late, don't leave it to fate

but I am selfish
Some of us are lazy
Some of us are wicked
And some of us are crazy
They're all part of human nature
part of our psyche

I'd like to think we could work it out
but don't put your trust in me

Your Face

Your face is a work of art
it conveys feelings from your heart
The lovely blank canvass of your teens
Yeah, you could have been a beauty queen

But life for you was never a breeze
and at times it brought you to your knees
- short-term romances, too many fags
too many lines and so many crags

Each line and crag it tells a tale,
hiding secrets of the Holy Grail?
Your face is a work of art
You could tell if you wanted
but you keep us in the dark

You looked older than your years
It wasn't your fault, all those hopes and fears

Memories, etched in your face yet locked in your head
Will stay there forever, until your dead?

Yeah, in your head they will remain
You will take them with you to your grave

Your face is a work of art
it conveys feeling from your heart

The lovely blank canvass that was your teens
Yeah, you could have been a beauty queen

But life for you was never a breeze
At times it brought you to your knees
Short-term romances, too many fags
too many lines and so many crags

Each line and crag it could tell a tale
It could hide secrets of the Holy Grail
Your face is a work of art
You could tell if you wanted
But you keep us in the dark

You looked older than your years
It wasn't your fault, all those hopes and fears

Your face is a work of art
It conveys feeling from your heart
The lovely blank canvass that was your teens
Yeah, you should have been a beauty queen

Baby, Please Don't Cry

Baby, please don't cry, you know it hurts me deep inside
- I guess a bit of neglection

I then show you that you're mine, then for a while everything's just fine
- you just need a bit of affection

Then I find I can't get you off my mind
I think I failed to mention
that it's a two-way thing, not just a fling
that was not my intention

But you don't understand, you think it was all planned
or maybe my invention

Then I finally find, that you've made up your mind
and that you'll be moving on

I was sad to hear, that you'll be leaving me dear
I know you thought hard and long

I guess all I can give, is a goodbye kiss
and wish you all the best

I remember the times, I remember the places
but most of all seeing your beautiful face

I wish I could go, back there right now
and have a second chance

- But no, you can't turn back time, and I blame myself
the fault was mine
it's a learning game indeed, is this romance

Creativity

Creativity [Cre-at-iv-ity]
Comes in many forms and guises
Creativity
All kinds of colours, and shapes of different sizes

If I'd known what I know now
I guess I would have worked it out some how
But no, there were too many
Restrictions [Re-strict-ions]
Shouldn't have been influenced by other peoples opinions
[opin-ions]

Creativity
Comes in many forms and guises
Creativity
All kinds of colours, and shapes of different sizes

Sometimes I struggle, I should have faith in my ability
Knowing that I do have the facility [fac-il-ity]
Yes to work it out and who knows may-be
I think I might just make it this time baby

Creativity
Comes in many forms and guises
Creativity
All kinds of colours, and shapes of different sizes

I like it when you do your thing
I like it when you start to sing
and baby I really dig your new moves
especially when you start to groove

First discover who you really are
and then you'll find that you will go far
and you'll start to care about the things that you do
and the impact of your actions on those around you

You've reinvented yourself again
and given yourself a brand new name
You adapt well to a changing world
keep going and you'll win this game

Creativity
Comes in many forms and guises
Creativity
All kinds of colours, and shapes of different sizes

Magic Box

I live in a magic place
with my brothers and sisters of the human race
I've just realised from what I've seen
what a really great place I live in
Never knew it, just because-
It's like living in a magic box
No one could see from the outside in
And I never knew where I'd been

I suppose I'd been dreaming with my eyes closed
- and all of a sudden I awoke
to the sound of laughter on the breeze

Now I'm looking from the outside in
never knew where I'd been
But now I can hear things that I'd never heard
and appreciate the joy and love in the world

I can now see the sun in the sky
and not just the darkness of the night

I live in a Magic Box
Never knew it, just because-
Just because it's all I'd known
and some things you're never shown

Hearing the laughter all around
I can now see beyond this town

I live in a Magic Box
Never knew it, just because-
I was lookin' from the inside out
Now I know what it's all about

Gotta look at things from a different angle
- gotta use my mind
Gotta look at things from a different angle
- see what I might find

Different perspectives can mean different things
to different people, like diamond rings
- Any gem should do if it's given with love
but to many it simply would not be enough

Look at it this way, look at it that
If it doesn't look good then take it back

But we're so lucky because-
We live in a Magic place
Never knew it, just because-
we were looking from the inside out
Now we know what it's all about

But it doesn't seem real I know as
if it were we'd be so small
insignificant, and not so tall

- far smaller than a grain of sand

blown in from an African land

I look to the mountains and see the rocks,
pinch myself and give thanks for the Magic Box

You'll Make it Through

You've fallen off the rails just lately
You're too far-gone to find your own way back lady
Just too far off the tracks now maybe
Now we all need a helping hand sometimes baby

It's no ones fault just circumstance, the way things happened
to turn out, if she knew your mum would be saddened

You gotta pull yourself together
take stock of the weather
You can work it out

You are much tougher than you look
You're not easy to read, not an open book
but people think they know you
They have stereotyped your kind
'pigeon holed' you but never mind
You are an individual with feelings
not just a number, but a real human being

And who are they to judge you anyway
those self-opiniated types
They think it's always black and white
It's easier for them that way
but they don't often get it right
and it's you that have to pay
the price for the way they behave

Trust me I know you and you will pull through
but you'll have to dig real deep
if anyone can make it, it's you
Inside you have the power and resources
Have faith in yourself and yes you can make it too

Cold winter

Please don't leave me alone baby
but you left for the South of France
you didn't even give me a chance
to express myself baby

But one thing I guess for sure
the weather's much kinder there
especially this time of year

And I know I'll miss you more
- much more than you will ever know
but why did you leave me here
standing all alone in the snow

The weather here's starting to freeze
and my frozen tears have brought me to my knees

You hurt me to my core
If only you'd loved me just a little bit more
but unfortunately
It was never meant to be

So goodbye baby

I wish you well, take care
I'll miss the colour of your hair

I'll be thinking of you though
while I'm wrapped up against the cold
You left me here all alone
How I wish you'd pick up the phone

But I'll have to keep on - keeping on
keep on trying to sing my song
and one day you'll hear it
and even sing along
and might just think of me
and the way thing used to be

Down here is where It's At

Down here really is where it's at
You can feel the love of the people
- each and every one of us a miracle

I look up to the heavens but for all its beauty
- the stars of the night sky shining bright
I cannot help but think it's such a pity
that it is missing something
being such a sparse and soulless, lonely place

For all its vastness and infinite size
There is no love that dwells there
- at least that I can see, no truth, no lies
no real people like us, lows and highs
aspirations, dedication, love and kind

Take a second to look around you – tell me what you see
Everywhere there's some measure of kindness
- love being given or waiting to be set free
people sacrificing things for loved ones and giving
Yeah without such things, life would not be worth living

We should make the most of life, you and me
for we represent no more than a microsecond in infinite
- some 'side road reaction'
as if we were never meant to be
But at least we achieved some history

Yes we all play our part
In this cosmic backwater
that is planet Earth

Drive (Thinking of Friday)

On the road again and all I can see
are devils eyes looking back at me
I put my foot to the floor
in a quest to make them history

Devils eyes, devils eyes looking back at me
Devils eyes, devils eyes it feels like I've been driving for eternity
Devils eyes, devils eyes and I'm startin' to feel weary
And I ask myself 'is this the way life's meant to be?'

I pull in off the highway and it's back to reality
As I enter the car park of some motorway cafe,
I need a cuppa coffee to perk me up
Give my baby a call, and if there's time, have another cup
But it's not long before I hit the road again
and rejoin all the other drivers and white van men

I'm a driver, I'm a driver
I got time to sit and ponder
I'm a driver, I'm a driver
Plenty of time to think and wonder
What, if, how, when and where
I'll keep on keeping on 'til I get there

I can't wait until Friday
when I drive home to my baby
Thinking of her makes me crazy
all I want is to be with my lady

Friday afternoon drive-home, I'm feeling great
put my foot to the floor, I don't want to be late
thinking of when I put the key in the door, I can't wait

And how I adore the weekend
Spend time with my lover; she's my best friend
I know that while the sun shines I gotta make hay
For I know it'll soon be over and the skies will be grey
As I head back to work in the early hours of Monday
on the road again - thinking of Friday

Last Chapter of an English Love Song

I say I love you but the words are hollow
for my heart is heavy and full of sorrow
What if I were to pack my bags and leave tomorrow?

This is the last Chapter of an English Love Song
Looking back I wonder where it all went wrong
I'm gonna pack my bags, I feel I no longer belong
here any more now that all the love has gone

As the last train reaches the end of the line
and the rain washes away the once-fresh snow
You don't need to be a clairvoyant to read the sign
There is no choice, there's only one way to go

Was it me; was it you or something beyond our control?
I haven't got any answers and maybe we'll never know
why it all went wrong and things ended up so low

We got lower and lower 'til we couldn't even appreciate
the sun setting in the west,
and how sad is that?, it just goes to show we failed the test

Now that autumn's on its way we'll be one year older
The swallows are long gone and the weather's getting colder
and this winter we won't be keeping warm together

And if I thought for a moment we even stood a chance
I would return right now for that 'second dance'
But no, our chance it came and went
Call it fate I think, it was never meant
to be, at least not for you and me
so I'll just get on with my life and let it be, yeah let it be

Me, myself, I

Me myself I, you don't need to ask me 'why?'
You know it's all about me and me only, can't you see-

The world is my oyster, I can do what I want
I have been taught that I am the best
I'll get what I want at any cost
Why ever not, sod the rest

Let's make bucks at their detriment
I care about me and it's money in the bank
Don't think about them, for they are weak
and so to the bottom of the pile they have sank

I put them there, how proud I am
- powerful, spiteful and self egotistic
that is my motto, that is my logic

I won't be happy until I rule the Earth
and at any expense for that is my worth

(Yes I know your 'type', I've seen you before
but only this time you wanted more)

Love Light

If there were no darkness, there'd be no light
Think about it baby and tell me if I'm right

When it's very black, in the dark of night
even the faintest light can seem so bright

But sometimes that little light's all you've got
- so hold it tight

The chances of it working out
sometimes don't look that good
But when you've got nothing
It's well worth a shot

- not for them maybe, but at least to you
for when you haven't got much
you have a lot less to lose

Some do not believe
that the things that they dream
as real as they may seem, will ever come true

Hold on tight, hold on tight to your hopes and dreams
Hold on tight, hold on tight and let your love shine bright

That's what counts
it puts everything else in the shade
so powerful is this Love Light
it has a brightness that will never fade

At some point things will change around
you just need a little patience
so quit being down

Hold on tight, hold on tight
and have faith in the Love Light
and even on a cold, dark night
you'll feel the warmth and see the way ahead

And should you find you have any spare
please shine some my way
cos I'd really like to stay
forever and a day
in this Love Light

So One-dimensional

You're one-dimensional
- you think about the money
One-dimensional
I don't think it's funny
One-dimensional
It's time you thought about the
people

But no, not you
you're egotistical
But no not you
- A democratic criminal
wrapped up in your own little world

You will give a helping hand
only if there's something in it for you
Because you don't understand
the reality of generosity and truth

With you it's all just an act
statistical manipulators twisting the facts
still you're ahead in the polls, another good year
I loved you once, but what do you care

You're too busy looking for the camera
for your next photo opportunity
You double-check your image in the mirror

and you like what you see
but at that point you've missed your moment
of what really matters and everything that you could have
been

OK so you got voted in again
But:

You're one-dimensional
You think about the money
One-dimensional
I don't think it's funny
One dimensional-
It's time you thought about the
people

Love-Look

I can see that 'love-look' start to glisten in your eye
but with a hint of sadness there, 'why?'
Is it something you've tried to bury and close your mind to
that keeps resurfacing, coming back to haunt you?

I am not one to normally offer help
but with you I'm going to make an exception
I am aware that you need some help
I don't know why, maybe it's a means of redemption

- trying to redress the balance for some bad things
that I've done, and so with the love I bring

Girl you look on the bright side
come with me; let's take a ride
I wanna show you another side to this city
and just two blocks down she could see I was right
Things no longer looked so desperate in the light

You stick with me, I won't let you fail
I don't want you ending up falling off the rails
What am I doing, it says a lot
I guess with time I've mellowed and must be turning soft

Things just round the corner seemed a world away
to the place you called home just yesterday
as we danced together in the street
to some far off sound of a nightclub beat
We made a stand together
just you and me, hand in hand, no defeat

Old Newspaper

An old newspaper blowing in the wind
that's me – all washed and dried up
Please help me Father for I have sinned

I was once a star
- now I'm yesterday's news
and there is no longer a room with a view
Like it or not there's nothing I can do

But at least I have memories of my Glory Days
albeit somewhat faded at the edges
- there's less colour in them now
and they're starting to 'grey'

Sadly I can never return to that time and place
Only in mind
where I could feel the sun's warm rays
in the summer breeze upon my face

If you ever find yourself where I was
lucky enough to be
make the most of it and never waste time
Look close; can't you see its fragility?
Times move on I suppose
And my advice?

Try a little harder and be where you want to be
and make the most of your opportunity
Isn't that just great coming from me?

Tell me mister have you seen
that old newspaper blowing in the wind?

One Side of the Fence

One side of the fence is your world
- a champagne life of swimming pools
On the other side is my world
- one of JCBs and roadwork tools

I hear a splash as you take a dip
swim over to your private bar and take a sip
of fine chilled Chablis in the sun
Would you let me in when my work is done?

No, I thought not, still never mind
Cos I am thinking of the day
when I will win the lottery or write songs that pay
I would go and buy a gaff just like yours
with a guitar shaped pool with doors
that lead to a fully equipped gym
But I'd never lose sight of who I am and where I've been
anyway it's good to dream, good to dream

One side of the fence is your world
- a champagne life and swimming pool
On the other side is my world
- one of JCBs and roadwork tools

I hear a splash as you take a dip
swim over to your private bar and take a sip
of fine chilled wine in the sun

Would you let me in when my work is done?

Inherited family fortune, or wife of a city boss
who took early retirement after making a loss?
Rewarded for failure, it's what happens here
So it could happen to me, who knows by this time next
year
and so I'll put the champagne on ice for the moment
Keep dreaming and make do with my beer

Love Song 1

I cherish every moment with you
It's important 'cos something this good won't last forever
I cherish every moment with you
and time means so much when we're together

You are a wonder, a treasure of my life
and wouldn't it be nice
if we could stay together long enough to grow old
You mean everything to me; you are my world
you are such a pleasure in my life girl

You and I, our hearts beat as one
I can feel the peace and love inside of me
That feeling of contentment and of joy
My cup now over flows, I was blinded by the light
My eyes adjust and now I can see

You are my dream come true
And all those precious moments with you
Our valuable times spent together
I hope it lasts forever

My love started as the tears of rain
started to subside, yes there was a lot of pain
but luckily that cloud had a silver lining
My love for you soon flourished
and the sun came out and started to shine

You fit my hand like a glove
my foot like a shoe
When we first met, we both knew
we would fall in love
And whenever you give it there is always enough
passion and tenderness that's our love, me and you
and our Love Song number 1

Poison Pie

You can't have your cake and eat it too
but you, you're are an exception to the rule
'cos your mum works at the bakery at Timbuktu
but for the rest of us it's not the same

If I made love to her would she give me a slice?
I did but it didn't work out that nice
for she baked me a poison pie

(Yes she baked me a poison pie
baked me a poison pie, baked me a poison,
baked me a poison, baked me a poison pie)

As I hit the deck I remember looking up and asking
why?
'To help save the planet, one less mouth to feed'
she liked me in a way but not my greed

She had laced it; I was feeling high
As I headed up toward the sky
A one way ticket only on this flight

The bakery's been closed for sometime now
The windows are all boarded up
and as for the baker, she's on the run
The police called around and started questioning the son
She knew it was just a question of time

so she upped sticks and followed the white line
to take her to wherever it would find

She got her come-uppance though when
on route she bumped into three men
- all bakers from Abidjan
and needless to say was never seen again

Strong Metal

It's 30 degrees and rising
They say if you can't stand the heat to get out of the kitchen
and for many that's all the advice that they'll be given

But I'll tell you something they forgot to mention
If we were metals we would be made of steel
Strong in our love, because it's so real

While others fail, bend or brake
we never need to fake
For we love each other with all our hearts
the bond is so strong we will never part

I love you so much petal
Yeah, yeah we're made of strong metal

We're tougher, we're tougher, we're tougher than you
You mess with us and we'll 'run you through'

Strong metal, strong metal
We can take the strain
Strong metal, strong metal
We can take the pain

If things get bad then we'll turn them around
If you take us too high then we'll bring you back down

We don't listen to the bookmaker's odds baby
And don't mind being underdogs maybe
We're never gonna give up now
We were never just gonna roll over and lie down
For we're made of sterner stuff
We will win; tell us when you've had enough

We're gonna tear up the form book
If you don't believe it take a second look
and you'd better believe your eyes now petal
Cos yeah, yeah we're made of strong metal

Toast

Mass immigration
It's good for the economy
The long-term effects
do not bother me
I care about pollution
But won't cancel my holiday

You're not the only one
CO2 levels are increasing
The polar ice sheets are melting
and sea levels rising

And here everything is fine
sit back; enjoy the sunshine

Pacific islands are under threat
but don't worry you can go by jet
to see them for one last time before they go
Take a few photos for prosperity and do a slide show

The worlds' population is expanding
you better keep up with those lunar landings
putting men on the moon
At this rate there'll be the only ones left alive pretty soon

And there'll be up there looking down
wondering how it all came about -

Looking back at a sad lonely place
that once was home to the human race

………………………………….. *2nd slice*

Anyway what can we do today?
It seems we cannot win it's a 'catch 22'
Perhaps spend the money from social care
to convert carbon emissions and clean up the air

You set up a smoke screen
looking back it was no surprise
at least we opened up our ears and eyes
and could see the truth through your lies

And everything you paint is 'fine and dandy'
in our world everything is swell
Paper over the cracks again, your good at what you do
granted, block up that window, suffering is spoiling the view
For you deceive me almost every time
And so I'll look a little closer
- and try and read between the lines

Nuclear power stations being built but not maintained
by once rich nations showing money-pains
They helped to keep an aging, growing population alive
I suppose something had to give
The love of people vs. that of the earth

We've had our cake and we have eaten it too
with a ravenous appetite, we bit off more than we could chew

Us choking gluttons what can we do?

Are we parasites that are killing our host?
I hope not but it's a scary thought that
as I put on the radio and make some toast

This Key we Forged Together

For someone so nice I'm privileged you like me
It just goes to show you never know what might be
when you find the one you've been looking for
don't waste your chance, yeah and 'give it some more'

We've got this key, we both forged together
It opens up doors we once thought would never
open at all, yeah we're having a ball
I pinch myself and hope that this goes on forever
Yeah, yeah, yeah forever

You from the start knew so much more about me
than I first realised, was I really that easy to read?

And when I look at you
all I wish to do
is hold you in my arms

I'll be there for you
Anytime you need me to
To me you're so beautiful
and I'm so in love it's true; please stay

And be mine forevermore
It's like you've opened up a door
to heaven in my world
where all my dreams come true

because I am here with you
Please hear and understand me girl
when I tell you the things I do

Star?

Please, please forgive me for I have many butterflies
Inside of my stomach and my throat is a little dry
but I won't be giving up, for I will always try
Take a close look at me and you'll see it in my eyes

I guess I should have gotten used to it
- standing up here on my own
So many of you out there
yet I feel so alone

I will raise my voice up baby
and try and sing clear and loud
And at least I will have achieved something
- if I can only touch you and make you feel proud
maybe bring a lump to your throat
or a tear to your eye

You see I'm just an ordinary geezer (girl), an ordinary
guy
who's just starting to believe in himself (herself)?
And starting to fly

Yeah, yeah, yeah I'm gonna make it through
Yeah, yeah, yeah please have faith in me
Cos I hope I am growing, shining here right in front of
you
Maybe like a star or a sun

So please believe in me
as I try my best and sing my song

Have a little faith in me
put me where I wanna be
- High up on a pedestal
elevated in this Hall
of talent and of fame

It's Time to Make a Stand

I drive past slow
- there's a cross on the corner
where the grass used to grow
with cut flowers around it on the ground

It's almost like a déjà vu thing
like I've been here before
As if someone's trying to tell me something
like an old video I once saw
running in slow motion in my mind
but although I really want to
I can't quite see the end

I ask myself 'why?'
Cos I don't understand
How this could ever have happened
In this modern, 'civilised' land

It's time to change the plan
Yes it's time to make a stand

The moon is shines bright
As the sun sinks slowly out of sight
Flickering lights from across the river
reaching out into the night

And while the city sleeps

and the moon looks down on our world
at the druggies who play bo-peep
with their lives - they're gonna paint the town red
In more ways than one
At least they had a choice but what of the innocent
who won't be waking up in their beds?
But what can we do, man?

It's time to change the plan, time to make a stand

Never to have seen the Sun

Never to have seen the sun
'How Sad is that! but yeah, yeah, yeah you're not the only
one
Never to have seen the sun
It must be a time for a change of direction

Just imagine living your life on the north-face
- never knowing any different
Living blind in a dark place
- content but without sentiment

Never to have seen the Sun
'How Sad is that! but yeah, yeah, yeah you're not the only
one
Never to have seen the Sun
It must be a time for a change of direction

How good things could have been
- splashes of colour, rainbows never seen

I should have looked up long ago
rather than looking down
and seen the light that was always there
but I was looking at the ground

Never to have seen the sun
'How Sad is that! but yeah, yeah, yeah you're not the only one
Never to have seen the Sun
It must be a time for a change of direction

So Romantic

It's cold outside
Tumble weed blowing through the night
And I love you
I want to keep you warm
I'll wrap my arms around you
and give you shelter from the storm

There is no other
Our love is true
when we're together
we're never, ever blue

You and I, we shall never part
we love each other with all of our hearts
I love you more than ever
as each day's sun goes down
I'd like to be with you forever
and hope that you'll always be around

Singularly we would be peasants
of this rich kingdom all alone
But together we're so strong, so noble
like a King and Queen upon the throne

Romantic [Ro-man-tic]
That's what I am
Romantic
Girl come take my hand

You are the sunshine of my day
and the moonshine of my dreams
loving me for what I am
Tell me have you seen
the rays of light from across the stream

Bucket loads of love
you calm the stormy seas
allowing the white dove
to fly upon the breeze

I simply cannot get enough of you
you and I are as one
You are my soul mate in this life
please never leave me honey
for it would be like an endless summer without a sun

So romantic
Girl come with me
So romantic
And you will see

Come lay here, just you and me
My chosen one

Another day in Dreamland

I awoke to another day in dreamland
life doesn't always seem that real to me man
I suppose life must have been too kind,
as I don't have to scrape and find
just enough money to survive
like some places in Africa
where it's a daily battle just to stay alive

And as I walk down my High Street
there's a lot of long faces
even in the car park
people are fighting for the spaces
and I ask myself, why are we not happy?
and think if we knew what we should, we ought to be

You cannot appreciate things that you don't know
so just think, expand your mind and let it grow
put yourself in their shoes, if only for a moment
feel the pain, the sadness and the torment
- you will know that, yes, life can be cruel
and that this may not be such a bad place after all

Glowing Embers

Glowing embers from the campfire on a starry night
floating in the cool breeze
Here and gone in the blink of an eye
but we still can't see the wood through the trees

Life's too short to keep looking back
to the things that might have been
It's in our hands here and now
You can shape your own future – use your vision

So don't leave her standing alone in the cold
do something and watch the future unfold
In front of your own eyes 'here and now'
Have faith in yourself, you will know how

I Remember When…

I remember playing with the girls in Central Park
having fun all day until the sky grew dark

We looked over at the shimmering lights of the City
The girls admired them, thought they looked so pretty

Yes I remember when

I remember past holidays in the sun
The days seemed longer then and full of fun
I remember the kids first day at school
and making them laugh by acting the fool

Yes I remember when

I remember Christmases in the snow
Wishing those times would never go
and last forever, for eternity
But I know things don't – for it's not meant to be

I remember when the sun used to shine so bright
We've been lucky I guess, you made a dark place light

Yes I remember when…

Spare Part

I went somewhere different today
not for an exotic holiday
but some place where you can't get more real
down at the 'breakers' you can make a deal

Dogs running loose all around
eating scraps of leftovers off the ground
left by the punters at the burger van
- radio blaring playing the latest sounds

Down at the breakers, budding Freddie Lakers
down at the breakers, budding money makers
wheeling and dealing, long days working hard
Yeah recycling the old parts of the cars

No 'airs nor graces', 'money in your faces'
no PC action or union affiliation
after rain it's a muddy mess - no disabled access
equal rights are pretty useless

And Michelle that works the burger van
she's still looking for a man
Her smile brightens up the place, especially on a dull day
- she's got a wicked laugh that blots out the DJ
and its service with a smile as she hands me my burger
as I turn and leave with my spare part for my [me] motor

Tell Me; Has the Mystic Seen?

I didn't know where you were coming from
I'm not in to astrology
-so please accept my apology

It was never my intention
to mislead you with false hopes and invention
please forgive me honey - I'm only human

I was tempted by you
and I found you very cute
but who knows maybe
we could've been the perfect match lady
given a different place and time

But like two ships passing silently in the night
in the cold, dark starry sky
never really knowing what just might
- have been, tell me has the Mystic seen?

There's Nothing in It

The day goes by so quick
there's nothing in it
It starts off sun, then the rain comes along
there's nothing in it

It's not good to waste your days away
but that's what I've done
We had a good night, burning real bright
yeah really good fun

The saying's true, like you always knew -
'don't burn it at both ends'
but we had a great time, yes real fine
with you and all my friends

Same time next year, if I'm still here
yes I'd do it all again
so I'll sign off soon, with all my love
and hopefully see you then

It's not good to waste your time
writing all that rhyme
and anyway what did it do for you?
Something different I guess at least that's true

It makes it worth the while
just to see you smile
Oh and thanks for being mine
you are simply the best
and oh so fine

Do I think you're my soul mate?
yeah I think you're real great

Get outta bed, can't get you out of my head
there's nothing in it

She's young and beautiful, long blond hair
I should not get involved, but what do I care
and anyway there's nothing in it

Please don't start, cos like your heart
there's nothing in it

I walk down the street and I've got cold feet
but I can't feel them
All I think of is you and the things that you do
but there's nothing in it

Your Streets

You've got two eyes like me
so why can't you see
what's happening on the streets, your streets?
Yeah your streets

I look out from my motel window
and see neon lights flashing, advertising
they're drawing me in
- attractive yes, but I know that they're faking

It's so cold outside but things look so warm
Things look so slow, but things are happening
wheelers and dealers plying their dirt
like lovers hand in hand, will it ever work?

For some maybe 'yes' but mostly 'no'
if only they knew it was time to go
One block down girls are trading
their self-respect for cash
to buy their two minutes of happiness

I refocus and see my reflection
staring back at me superimposed
on the love and trash
that is the world below

Sir James Montague

So what are we going to do
to make it through?
it's not that easy
unless your blood is blue

Like Sir James Montague
like Sir James Montague

An automatic job in the City too
to buy and sell shares but you weren't aware
that we've been watching you
we've been watching you

Putting profits before pride and honesty
and you don't care who gets hurt
in your selfish pursuits along the way
You'd steal the ale from a monastery

They made you a knight
for 'services rendered', you've got more money than is right
Sir James Montague, tell me is your blood really blue?
'Yes of course and let's face the truth -
it was only ever about me, and never ever you'

New England, USA

If we knew what the future held
& on knowing see how we felt
I am sure you would prefer
not to know, no not ever

Because life, whether we like it or not
only ends one way
and loved one's cannot stay
So live your life for today
Tell them how much you love them
and cherish them just in case
you don't get the chance
to say your last goodbyes

You never know what's round the corner
you cannot see
- someone over the white line perhaps
doing ninety-three
I wonder why, was it the thrill of the speed
But regardless that's no consolation for you and me

If we knew what the future held
& on knowing see how we felt
I am sure you would prefer
not to know, no not ever

'Snap!'

A girl's laughter carrying on the breeze of a cold winter's night
Walking past the shops lit from inside, looking warm and
bright

A complete contrast of worlds in one street
- One comfortable and warm, the other 'ice-cold sleet'

Childlike memories and dreams but I never go in
even though the light beckons and seems so inviting

Anyway I've got to head homeward bound
or I'll miss my bus from the centre of town

I run hard to get there but of course it's that time of year
And have to sit there and wait - in the freezing concrete pill
box of a station with the wind blowing through until
The bus arrives, I take my seat but can't see out
- just misty reflections from inside on a black
background

I rest my head against the glass
with the metal frame with the mould
bumping to the tune of the potholes in the road
Is it just me or am I getting old?

'Snap!', I think back and remember it was sometime in December

and a girl's laughter carrying on the breeze of a cold winter night

Walking past the shops lit from inside, looking so warm & bright

Politician with the Iron Fist

The politician wants to rule the world
but he doesn't understand
or care for the poor girl
on the corner with no gloves for her frozen hands

Or the guy that's just been made redundant
He worked real hard, but for what?
someone else's greed and gain
but it's not his fault
- there's always someone else to blame

Politician with the iron fist
we all thought at first you were the best
However time saw through your lies
it should have been no surprise
that you were like all the rest

You'd sell your country down the pan
just to be perceived as a bigger man
a 'main player' on the scene
I guess like many of those before you
and most that will ever be

The River

I walk right down beside the lazy river
I walk much faster than it does flow
I've got a date with destiny see
and anyway have nothing better to do

I don't know if she'll be there
or that she will show
but I'll find out pretty soon now
as I'm getting close

When I get to the place to meet you
the place of the of rendezvous
there's no one there to meet me
I guess they'll be no 'me and you'

I wait a while and just like the river
time seems to pass so slow
a bit like living in a village
in the middle of Idaho [I-da-ho]

After about half an hour
I'm just about to leave
when you turn up and cross my palm with silver
- who was I to disbelieve

and I've never looked back since
your future's in your hands
So don't just leave things to chance
by sitting on the fence
and you'll find romance

Girl

I often ponder – 'where does my future lie?'
Is it what I'm doing, or shall I pick up my pen and write
some Love Song that may just touch your heart

I've been with you for so long baby
I love you more each day
I love you so much lady
-please never go away

If for any reason you were no longer here
it'd leave such a vacuum inside of me
Listen to my song darling and you will see
It'd be like the Earth without the Moon, Stars without
a Sky
Rain without a cloud now honey
I hope it's always gonna be you and me

You've got to know me better than I know myself
And I've got to know you just the same
I don't need to tell you that I love you
Because with me you already know
there's always an open door
and I'll always give you shelter or more

Even though you already know, it doesn't hurt me to say
I've been with you for so long baby
I love you more each day
I love you so much lady
-please never go away

The Tree Song

I once climbed a tree
- yeah thought I was real high
cos I was with the birds
I thought I could fly
but (of course) I came tumbling
down, down, all the way down
crashing straight down and in to the ground

But I liked what I saw and wanted some more
and so climbed a hill, high above the city
The tree looked so much smaller than before
and with the lights of the town
the view looked so pretty

It became my favourite spot
Well up above the parking lot
as the sun sinks slowly down
below the horizon
I feel as if I never want to leave
And all my senses seem to please
so I guess it's not surprising

I look up and see the stars above
and realise everything is relative
I am one over infinity
but I still count because I breathe
I pinch myself to make sure that I'm not dreaming

By rights I shouldn't even be here
the odds are way beyond compare
and to think I have loved and known you
Thanks so much for being there

I wished to go higher still
- further than most ever, could or will
and so took to the mountain range
I did it because it was there to do
wow!, what a wonderful view
And looking up I saw an eagle
eyeing up a seagull
Who was watching a spec of dirt
- but that was only me though!

Everything

We think we know it all
but we sure like to spoil
everything, everything

All the things that we touch
seem to turn to dust
everything, everything

Things are not as they appear
and not as rosy dear
as they would lead you to believe
It's in their interest see
But that's no use to me
for all that I can hear
Are the words still ringing in my ear
'everything', yes, 'everything'

Time Machine (London 1963)

I'm young and free
won't you come with me
in my magic box of a time machine?

We can go anywhere
I don't care
How about London 1963?

or add a year or two
and we'll go and see The Who
John, Roger, Pete and the great Keith Moon

We can take a stroll
down the road
and see if they were really paved with gold

We can go anywhere, do anything
see things that we've never seen

We could go and see the Beatles and the Stones
Pistols or Ramones
Or have Christmas all over again with The Pogues

And once we've visited the music scene
look back and marvel at where we've been
We can travel across space and time,
visit different worlds, produce our own wine
Have a glass or three in a distant galaxy
Yeah take my hand and come with me

And then she said,
'But there's only one thing
when we're finished please bring
me back to London 1963'
(and who was I to disagree)

You're Still My Girl

You're still my girl
even though you are getting older
And you can always have my shoulder
to cry on if you want to
And if you need me to, I can hold you
protect you and stop you feeling blue

I didn't hear, please tell me again
I really love it particularly when
you whisper sweet things in my ear
- sometimes naughty, sometimes sincere
You are so much more to me than a friend
as we walk through the park hand in hand

In tune and step with the sound of the band
You like us a lot, but I'm *your* number one fan

I love you, but not all your ways
especially when you misbehave
No one's perfect I hear you say
And you've got a point – especially when it comes to me

I will always love you; you're still my girl
even though you are getting older
And you can always have my shoulder
to cry on if you want to
And if you need me to I can hold you
protect you and stop you feeling blue

Forever 21

Hey sister you took the wrong road
why did you do it? I don't know
Was it 'down-town peer pressure'
bad crowd, short-term pleasure?

What started out as 'big fun'
soon turned sour for everyone
in your group as you soon became
lowlife losers, nothing gained, nothing won
Why did you do it, I don't know?
Could've been peer pressure, I suppose
weak-will, drugs overdose
they call it fun, but I don't

Oh no, what have you done
don't die young, Forever 21

Don't get caught in that rut
and don't be so weak
have you forgot
it's a brand new day tomorrow?

And good things are gonna follow
It's in your hands and up to you
have faith in yourself and you'll make it through
Yeah, yeah you'll make it through

...........................

You little selfish thing
what have you done?
Forever 21

They'll always be questions
what, if, why, may be
things had turned out differently

Don't be surprised if you can't see
cos you won't have no eyes
no heart or feelings of emotion
what a waste, what a notion
no don't be surprised

You never did what you were told
Hey sister, you took the wrong road

Oh no, what have you done
don't die young, Forever 21

After Dark

She's been walking in the park
she's been seeing someone after dark
Doing things that she shouldn't do
to someone she once loved

Looking back I should've seen the signs
and read between the lines
And known things weren't that fine
when I think of all those lies

And now enough is enough
Because you're not the only one
who's fallen out of love

The day I found out it was all over
It was like being knocked off my feet by her
It's like she burned my four-leaf clover
And the first time I didn't feel quite so tough

If only I had known then what I know now
And your impact on me and how
you'd bring me down, oh so down
no wonder it's all over

It's not so much her but the time I can't replace
Yes she's been playing away
My day's turned cold and grey
I should have known she wouldn't stay

English Rose

Like a leaf floating in a stream
I know it really does seem
that we have no control over our direction
Swept along in the tidal surge
we have no influence on our destination

Heading one way with the flow
- an ever-changing path mapped out before you
Drifting then speeding up at the rapids
going under and hoping to rise again
In many ways love can be the same

So tell me have I lived up to your expectation?
I hope so, although I did leave one dark night
with some idea of being free
to avoid the danger of suffocation, but my eyes were
closed, I couldn't see!

that you're simply the best thing to happen to me
Yes we had our bad times, our highs and our lows
like the British weather in summer time
But I'll tell you something lady, the one I chose
all those years ago, I love you so much, my English Rose

Forget the Red

I texted you, you said you'd be here soon
No sooner than I'd put the phone down you arrived at
my room
'I didn't have a chance to chill the white'
'I've got a bottle of red' she said, 'so that's alright'

I asked her if she wanted some food, perhaps a takeaway
She replied 'foods for wimps' and just wanted to play
She took my hand after a glass or two
and led me down to the bedroom
I pull the curtains; it's cold outside
but we won't need any heating, at least not tonight

I later lay back and dream of what tomorrow might
bring
And somehow I just know it's going to bring great
things

Your bedroom light is on and you're all alone
Just like me, so I decide to phone
And today I am much better prepared
I've already chilled the white, so forget the red

Fast Food Diner

You wanted to step out, stand on your own two feet
You got a job down the fast food restaurant, to make ends meet
but the punters didn't see you as a person just as a means
of stuffing their faces, they may look but they won't have seen

- The lovely person that is you
but all they want to know is what's on the menu

At the fast food diner
do your best to show her
that she's not just a machine

Show some respect, you should never neglect
the people, you know what I mean

Think if it was you, how you'd like to be spoken to
when she gets your order for your food
- custard with your pie instead of cream

We all make mistakes
and a little patience would go a long way
in making this a better place

So next time you go there, and you visit you should spare
a thought for that girl as you wine and dine

Treat her good, treat her kind
or I'll kick your behind
After all she is our world

Meet me by the River

Meet me by the bridge at eight
And don't forget don't be late
'cos it's so cold down near
the river at this time of year

You're late as usual and it gives me time
to freeze and notice the fog
floating in the breeze
When I finally see
your smiling face coming toward me
I feel warm inside and I stop shivering
What's time anyway, all is forgiven

You take my hand
and we stroll through the mist
Its like there's only you and me
tonight in this great big city

You are all I need
I don't need anyone else ever
We're having a great time, despite the weather
I think it says a lot
And just in case you forgot
I tell you that I love you

While the city sleeps
What shall we do?

There's not much on TV
But when I'm with you
it never bothers me

Watching

I've been watching you
- the endless cycles of the sun and moon

Snow in the winter, warm summer sun
But tell me what does it matter anymore, if you're not
the one?

We will have to wait and see what tomorrow brings
there would be no time, no witness without living
things

Time is a measure, neither fair nor just
One-directional, a law without compassion
a means for history, memories and future dreams
based on our experiences and things that we've seen

I've noticed the fog in the winter sometimes hangs all
day
to the factory chimneys and high rise blocks
Picture it - damp and cold, grey on grey
Down next the river, down by the docks

Sometimes I breathe in the air and feel the despair
of the peoples within this hooded shroud
These working folk that were once so proud
I look and wonder 'will it always be this way?'
And think 'just may be forever and a day'

But today I sense a change in the atmosphere
and stare hard into the cold wind of adversity
blowing along the estuary in from the sea

Change is on its way
I should've learnt by now
That things never
stay the same forever

Yours sincerely

Sometimes I dream of a turquoise sea
there's no one else there, just you and me
strolling hand in hand along the beach
as the sun sets, low down, to the west
where red meets blue, you are the best

There's so little quality time these days
I'm so pleased we make the most of this place
I have to pinch myself, because life doesn't always seem real
as I feel this kind, warm breeze upon my face

You wave me off
from the front door
with the kids everyday
nothing could mean more
to me anyway

I love your red hair
and your skin, so fair
with your blue-green eyes
you were the answer to my prayers

I love you so much
and I'd like to thank you
for being my wife
and keeping the chill
out of my life

love yours sincerely me

Day Dreaming (Looking out the window)

Sitting in the meeting
listening to the bleating
I'm looking out the window
at the sun, day dreaming

The cloudless blue sky
reminds me of why
i've had enough of this place
My, how time flies
when you're having 'fun'
I'd rather be with you guys
out there soaking up the sun

'The company profits are only 52 (million)
and the Directors want bigger bonuses too
So this is what we're gonna do
- stop all inflationary rises for you'

Actions speak louder than words
It's time to impact on my world
I should appreciate
all the good things
I do, but just of late
I wanna do something more
How can I stay?

It's then I realise someone's asked me a question
'well what's your intention?'
'To leave this place
and get out of the rat race,
leave you all far behind.
I don't think you'd understand
but I've got a plan
I conceived it at this meeting
sitting here day-dreaming'

'By the way where's Serena
Tell me have you seen her
She speaks a lot of sense see
she say's 'the grass is greener'
on the other side
(on the other side)
This time I wonder if she's right
- Guess I'll find out pretty soon
As I get up and leave the room'

'Add it to your minutes
Departed half way through,
time's 10:35'
'what's he gonna do?'
'go, start a new life'
'Tell me Mr Chairman was it something that I said?'
'That promotion that we gave him
-It's gone to his head'

'But that was ten year's ago!'
'Was it really Fred?,
It's amazing where the time goes'
'AOB - stop people looking out the window,
day dreaming like that fellow'
As you make your way ahead

Life from a Park Bench

Life from a park bench,
Somewhere in South Greenwich

'People watching' in the park
After seeing Cutty Sark

Joggers running past me
Happy families holding hands walking through

Leaves blowing all around
Kids kick 'em 'long the ground

Lovers arm in arm strolling slowly past
So in love, you know it'll surely last

Cyclist riding by me
Past the trees and through the leaves

Feel Good Factor-there's love in the air
I wish life could be like this everywhere

'People watching' in the park
Better leave before it gets dark

Life from a park bench ooeeooeeoo

Summer turns to Fall

Would you like to be young
or perhaps older and more wise
Or just a fool like me wasting time
chasing rainbows across the skies?

It's something I just do and
maybe it's because of you
that I keep on keeping on

Perhaps I could try a disguise
and deceive you with some lies
But I could never really do that to you
because you were always so nice
and for that please don't apologise
- for in doing so you were the best

They say where there's a will
there's a way and as I'm getting older
I've got time to kill:

Youth is a priceless treasure
- as the old, educated, wealthy man can enviously testify
he's had his turn and knows you can never
turn back time, no matter how hard you try

And yes, he may live in a mansion
with servants to attend to his every beck and call
But he knows his remaining time here is short
and has noticed a change in the weather
Yes he knows nothing, no matter how grand, can last forever
as his summer turns to fall

Wonderland (don't rush)

I'll take you to a wonderland
where we can 'while the days away'
They'll be no problems making plans
and we'll do what we want to all day

The clear seas and the sand
just down from the bay
blue skies all around
and what's time anyway?

Island in the sun
I always knew you were the one
place I wanted to be
I've never felt so free

Don't rush, don't rush
it's time to take things easy
Don't rush, don't rush
this life does really please me

'High Rise World of Skyscrapers'

High Rise World of Skyscrapers

In this high rise world of skyscrapers
fast cars and high speed money makers
splashing the cash faster than the (L.A) Lakers
'but will you ever share the light?'

Looking up with the other faces
from one of the street's market stall places
Just a short walk down from the bakers
I'm thinking 'maybe I haven't got the head for heights'

We're too good for that
for that's where they do their
million dollar deals, pulling off the wheels
of the world's economy

But they don't seem to care
because they are aware
that we reward failure here

No they don't care 'jack'
if they get the sack
because they're made for life
buy a new Mercs for the wife
oh yeah

Who's paying for the pent house suite?
There's a pool on the roof, pretty neat
I've got a feeling that it's us down here standing on the street
eating our 'dogs that we've just bought from 'Mikes'

Any way I can't be bothered with it, at least not today
Because I've got you and you've got me
It's something more precious than all that I can see
And from where I am it feels so right
and anyway I'll tackle all that 'in depth stuff'
on another page, another day

I'll always be in a low place
but as long as I've got your face
I don't need anymore, I don't need anymore

Mariana Trench

I was drawn to you when I heard your call
I didn't see it at first
But looking back the writing was on the wall
And you're in free-fall, going down, down, down, down,
down, down
Getting closer to the ground, ground, ground, ground,
ground, ground

When you don't play by the rules
sooner or later you'll take a fall
When you play with fire you can only lose
And you're going down, down, down, down, down, down

Today you may be the 'It Boy or Girl' in the world
and top the bill
Don't get too carried away 'cos in the back of your mind
you know
there's only one way you can go

They tell you to be happy
but you can't quite respond
It's not that simple
And there's no magic wand

You acted your part
- Lived and breathed your roll
but went a bit too far

and now you're feeling under par
And you just can't sleep
Because of who you think you are

You tried a little Crack
To try to bring you back
You struggled, but it didn't work
and you got the sack
and had nowhere to go

You waste your day about town
and never felt so down
You need another fix just to bring you round
If only you had known

You started to look older than your years
All that paranoia and the fear
It would bring a tear to your eyes
And you never felt so low

If only you could go back
To a place and time before the smack
took a hold of you

You look in a mirror and the reflection's not true
You cannot accept it, 'cos you know it's not you
But you still can't get enough

You woke up on a city bench
Sick, tired, cold and drenched
It was the Mariana Trench (I'd guess)
Of your life

Dark Lady

Dark lady with the brown eyes
you kept me awake with your love-cries
I work the day but she works the night

We passed on the stairs
you looked so innocent, so free
as you bounced up past me like a breeze
as if you didn't have a care
with your black Caribbean hair
leaving a fresh fragrance in the air
behind you as you moved

What makes people do the things they do?

And hey, why is it you're having a lot more fun
than some of the other ones?

You've got a rare thing -
time on your side
you never rush
run or hide

I admire you Dark Lady
for your upbeat personality
You never seem down, even when most people
would have reason to be

You always take things as they come
and live from day to day
and look on the bright side that is the sun
in a light that will never fade

Brand New Day

I woke up in the morning
and thankfully it was the dawning
of a brand new day

This time the sun was shining
and the birds were singing
as they ventured out after the rain

It's like a different place
as I try to move on
from yesterday's heartache and pain

They say time can be a healer
and a cheat or either
But what difference a day can make

I should have known all along
that you would not always belong
here with me, by my side babe

It's time to draw a line under
what has happened and move on
We are only human after all
and like all people we sometimes get things wrong

Yes, thank you for this brand new day

Chosen Son

The sun's sinking casting on you
a shadow oh so long
It's so sad that you think
when you did you did no wrong

Despite the evidence
put there for all to see
but you still tried to hide the truth
you never wanted transparency

The winds of change are blowing strong
All the way from Liverpool to London
(and) to think that you were once our chosen son!

Reputations built on words
but not deeds
can fall so fast

What's been has been
and what's past is past
the strong will be weak
and the first last
(- the gravy train could never last)

So corrupt you lost our trust
we're the people that put you there
with whom you soon lost touch
No you never really cared for us

There's gonna be hard times ahead
Far worse than you forecast or said

The winds of change are blowing strong
All the way from Liverpool to London
To think that you were once our chosen son!

This whole episode has hurt me more
than all the rest put together that've gone before
I have a problem with all your greed
especially when you should be taking a lead
Guiding by example, a 'pillar of the community'
how I wish I'd somehow misread the situation
but no, you're a new creation

I know they're strong words
but you betrayed
the trust in you that was made
However what hurt us most of all
was that 'hand on heart' you could not recall
the plain and simple fact
that you honestly believed
you did nothing wrong in your part
in claiming obscene amounts to satisfy your greed
Taking money from those that need
It's an abuse of position and trust
and about time that you must

step down and go far away
and don't come back until you mend your ways
so it'd be a fair bet we'd never see you again

How can you preach to us
to tighten our belts and all that stuff

To say greed's just a part of human nature
Maybe, but you've pushed the boundary
way beyond the limit of where it's meant to be
To such an extent and redefined
the greed of man and crossed the line
You abused the faith and trust that the people put in
you
It's morally wrong and something most of us would never
do

So who are you to preach to me
you've undermined the grass roots and the tree
and the freedoms of our democracy

I feel let down and betrayed
by your actions of the day

The winds of change are blowing strong
All the way from Liverpool to London
(and) to think that you were once our chosen son!

All I want to do

You're all wrapped up against the cold city night
you've got a pink nose but you're looking alright

And all I want to do is take you home
wrap my arms around you and keep you warm
Take you back to my place
protect you and keep you safe

That's all I want to do

You can put your cold feet on me anytime
But somehow you'd never see me, never be mine

In the glowing lights you catch the mood
You've got a red scarf on and are feelin' good
Your eyes, like jewels, they sparkle bright
and how I wish I could take you home tonight

And all I want to do is take you home
wrap my arms around you and keep you warm
Take you back to my place
protect you and keep you safe

That's all I really want to do
but I keep my thoughts within
it's a sin and I know it's my fault
that you won't really know me at all

Nothing but a B-movie

Sun shines rays deflected by a cloud
radiating down creating a moving spotlight on the ground

Then rain drops on my window
moving to the tune of the wind
On-off migration heading south
distorting my view
Ahead of a grey backdrop scene
From a 'B-movie' that was once made
which they'll never show on TV
'cos it never made the grade

I somehow like it that way
that's 'me' -
yeah never gonna be a big star
never gonna get that far
So I don't care what you say
in your review
I'm always gonna be this way
and see if I care
but hold on there
isn't it time for something new?

One Last Thought

Miserable Harry got out of bed
Miserable Harry went to work
Miserable Harry got old and died
Miserable Harry – and no one cried

If only he'd known, it's not wealth or speed
that determine how far we get in life
-But actions and deeds

Index

Lightning Source UK Ltd.
Milton Keynes UK
14 April 2010

152743UK00001B/27/P